BOMBER COMMAND

Published by IWM, Lambeth Road, London SE1 6HZ
iwm.org.uk

ISBN 978-1-912423-53-8

A catalogue record for this book is available from the British Library.
Printed and bound by Gomer Press Limited
Colour reproduction by DL Imaging

Every effort has been made to contact all copyright holders.
The publishers will be glad to make good in future editions
any error or omissions brought to their attention.

Front cover: Aircrew from No. 106 Squadron RAF walking across the
dispersal area at RAF Syerston, Nottinghamshire, October 1942.

Back cover: Handley Page Hampden crews of No. 83 Squadron
are driven to the dispersal area at RAF Scampton, Lincolnshire,
on 2 October 1940.

BOMBER COMMAND

Rebecca Greenwood Harding

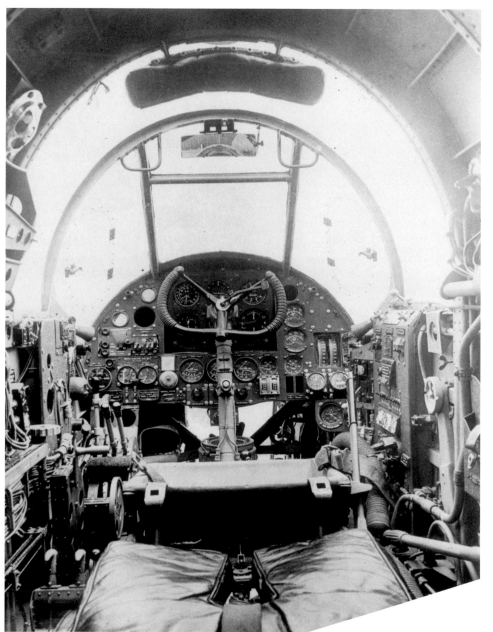

The interior of
a Handley Page
Hampden cockpit,
August 1940.

From 1936 to 1968, RAF Bomber Command was responsible for Britain's bomber forces. It played a central role in the strategic bombing of Germany during the Second World War and later maintained Britain's nuclear deterrent. For 32 years the men and women of Bomber Command served in many different roles in the air and on the ground, each with a vital part to play.

Bomber Command arose from the growing threat of war in Europe during the 1930s. With the expansion of the Royal Air Force deemed vital to Britain's security, Bomber Command assumed responsibility for Britain's bomber squadrons in July 1936, and Fighter Command for Britain's fighters.

As war approached, it was clear that Bomber Command's frontline aircraft, such as the Handley Page Heyford and Vickers Virginia biplane bombers, were ill-equipped to meet the demands of modern warfare. They were consequently replaced by faster, more effective monoplane bombers such as the Armstrong Whitworth Whitley and Vickers Wellington.

When Britain declared war on Germany on 3 September 1939, Bomber Command made the first operational sortie over enemy territory, with a photo-reconnaissance mission over Germany. However, Bomber Command was not yet the immense fighting force it was to become later in the war. Although the squadrons were larger in size and better equipped than those of the early 1930s, the crews were hindered by a lack of modern navigational aids such as radar, and early raids took place in daylight, making the bombers easy targets for enemy fighters.

When the war began Bomber Command crews were limited to only striking military targets, but by the summer of 1940 their remit was expanded to include industrial targets at night, using aircraft such as the Handley Page Hampden.

These strikes often had limited success due to difficulties in accurately hitting specific locations in the darkness.

Bomber Command was more successful during the Battle of Britain, playing an often overlooked but significant role by targeting the German invasion fleet gathered in French and Belgian ports, causing substantial damage. These attacks, alongside Fighter Command's dogged defence of Britain's skies, encouraged Adolf Hitler to initially postpone and then abandon his planned invasion of Britain.

The first raid against entirely civilian targets took place shortly after the Battle of Britain when British bombers raided Berlin in response to an accidental raid on London by a German bomber pilot. However, the appointment of Air Chief Marshal Arthur Harris as Air Officer Commanding-in-Chief of Bomber Command in February 1942 signalled a huge shift in policy. The Area Bombing Directive issued that month decreed that not only should military and industrial sites be targeted, but civilian targets too, particularly built-up areas. The intention was to weaken the morale of the German civilian population by targeting their homes and their workplaces. Bomber Command was ordered to operate at full capacity, reversing a decision from the previous autumn to conserve its resources following extensive losses caused by German air defences.

The introduction of the Avro Lancaster heavy bomber in late 1942 also marked a turning point for Bomber Command. Alongside the Handley Page Halifax, the Lancaster formed the mainstay of Bomber Command for the remainder of the war. Compared to earlier heavy bombers, like the Short Stirling, they were faster, capable of flying right into the heart of Germany and had a much larger bomb load.

The technological advances of the Gee navigation and Oboe bomb aiming systems significantly improved Bomber Command's accuracy to devastating effect. The number of German civilians killed by Allied bombs during the war is estimated between 350,000 and 500,000, and the near total destruction of cities like Dresden and Stuttgart provoked strong criticism.

The cost to Bomber Command was also enormous with 55,573 crew killed, 6,403 wounded and 9,838 becoming prisoner(s) of war. Personnel from across the Commonwealth served with Bomber Command, many of them never to return home.

After the end of the war aircraft such as the Halifax were retired and replaced with the more advanced Avro Lincoln and Boeing Washington. In 1951 the English Electric Canberra became the first jet bomber to enter service with Bomber Command.

In 1955 the first of the 'V bombers' – the Vickers Valiant – became operational, followed by the Avro Vulcan in 1956 and the Handley Page Victor in 1957. Together they formed Britain's nuclear strategic bomber force, primarily serving as a deterrent but also prepared to strike if Britain was targeted first. However, developments in Soviet missile technology in the 1960s left the V bombers highly vulnerable, and so responsibility for Britain's nuclear deterrent passed to the Royal Navy nuclear submarine fleet equipped with the UGM-27 Polaris missile system.

By the mid-1960s Britain's role on the world stage had changed as the British Empire contracted. The RAF was streamlined accordingly, with Bomber Command and Fighter Command merging in April 1968 to form RAF Strike Command. The legacy of Bomber Command lives on though, as seen in the photographs selected for this book.

Handley Page Harrows of No. 214 Squadron parked on the airfield in front of the hangars at RAF Feltwell, Norfolk, 1938. No. 214 Squadron was the first RAF squadron to be equipped with the Harrow.

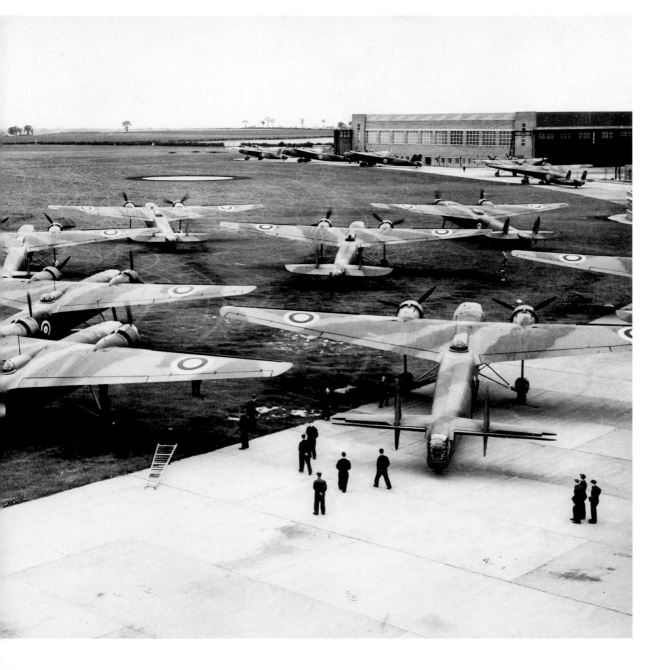

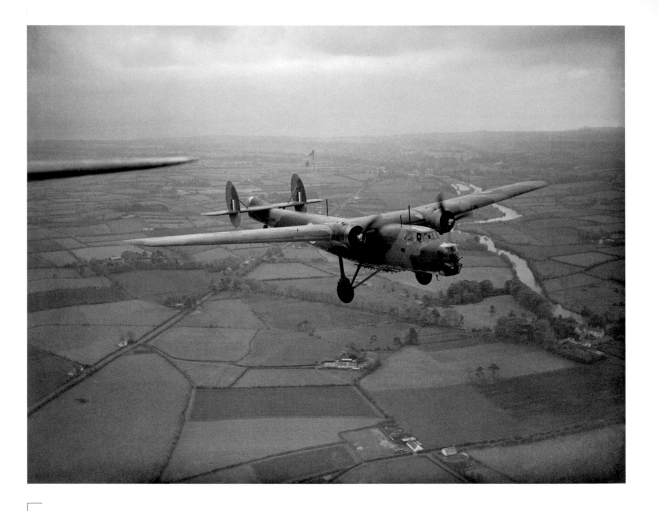

A Bristol Bombay on a test flight in 1938. The Bombay was designed for use as a transport aircraft as well as a bomber.

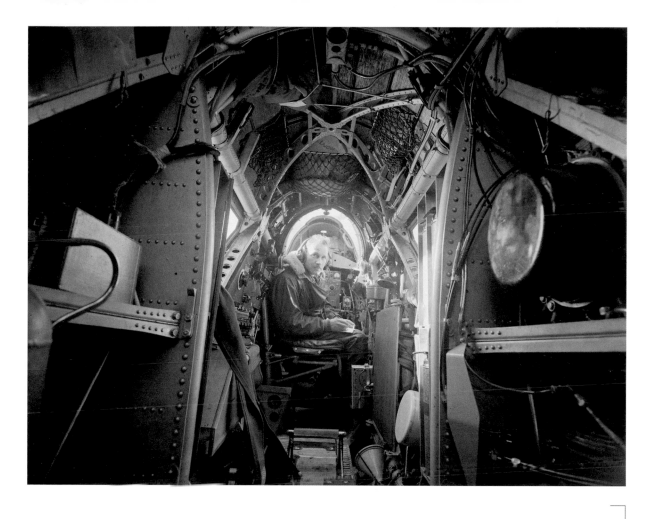

The interior view of a
Vickers Wellesley bomber,
viewed from the cockpit
to the observer's position.
Photo taken in 1939.

A Fairey Battle, likely of No. 218 Squadron, on a snow-covered airfield in France during the winter of 1939–1940.

A mobile Nash and Thompson FN-4A gun turret, as fitted to the Armstrong Whitworth Whitley bomber, is used for training air gunners at No. 10 Operational Training Unit at RAF Abingdon, Oxfordshire, 1940.

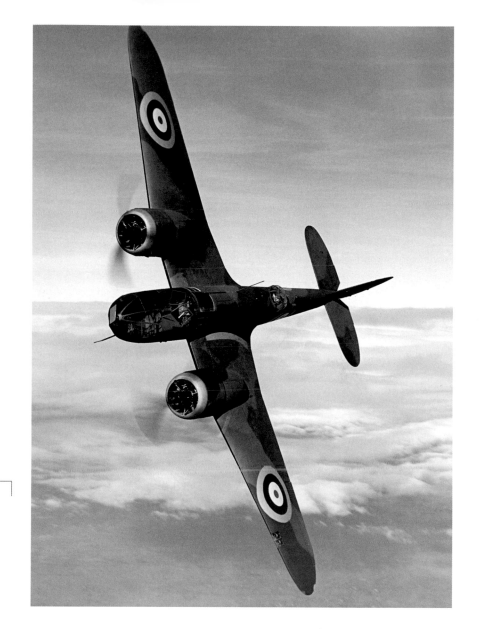

A Bristol Blenheim IV bomber banks towards the camera, 1940. The Blenheim's design originated from plans for an inter-war civil airliner but developed into a bomber due to its speed compared to other aircraft of the time.

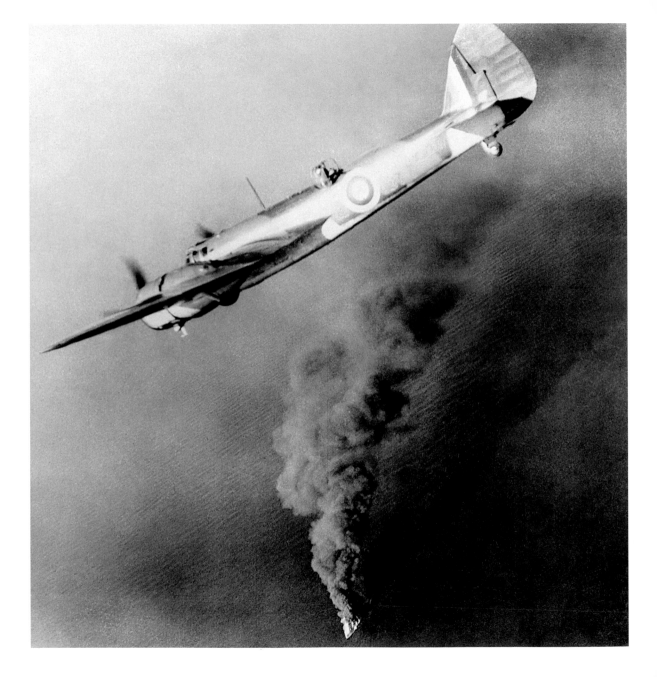

A Bristol Blenheim Mk IV, piloted by Wing Commander Basil Embry, the Commanding Officer of No. 107 Squadron, circles a British oil tanker on fire and sinking in the English Channel after a German attack in May 1940. The Blenheim's serial number and unit codes were censored by the British government at the time to prevent sensitive information reaching the enemy.

Bristol Blenheim Mk Is of No. 84 Squadron lined up on the airfield at RAF Station Shaibah, Iraq, August 1940. Shaibah was a small airfield in the desert, the use of which by the British had been guaranteed by the Anglo-Iraqi Treaty of 1930.

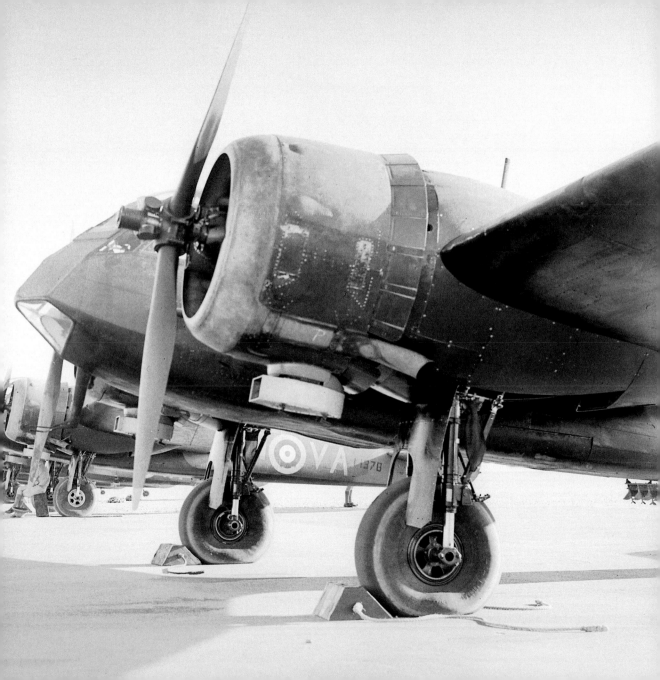

The interior of a Handley Page Hampden cockpit, August 1940. Hampdens were one of the mainstays of Bomber Command during the early years of the Second World War until they were superseded by larger, more powerful aircraft such as the Avro Lancaster.

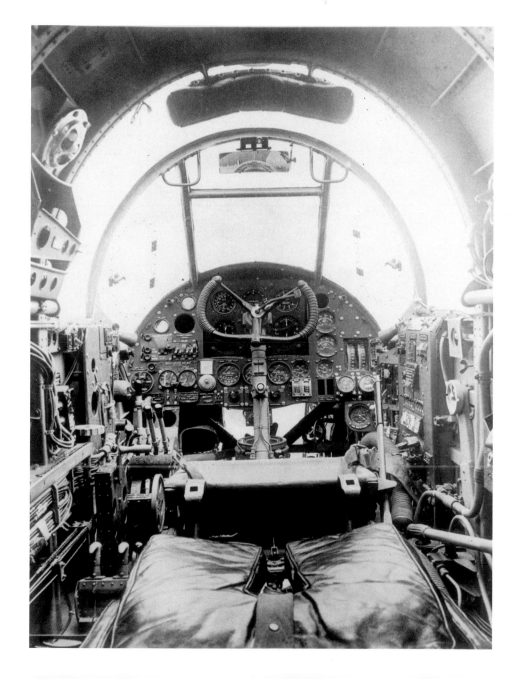

The damaged rear gunner's compartment of Handley Page Hampden Mk I, P1355, of No. 83 Squadron, photographed at RAF Scampton, Lincolnshire, after returning from a night attack on invasion barges at Antwerp, Belgium, in September 1940. It was during this sortie that the wireless operator/air gunner of the Hampden's crew, Flight Sergeant John Hannah, earned the Victoria Cross for his bravery when the aircraft was set on fire and severely damaged.

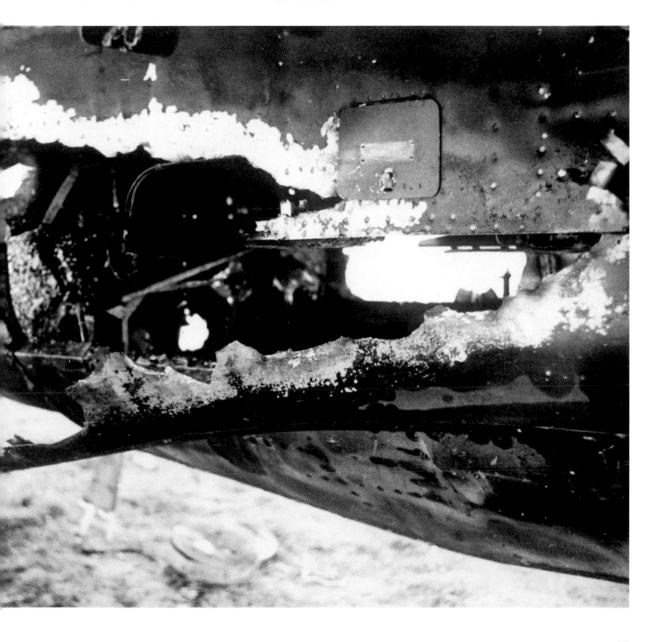

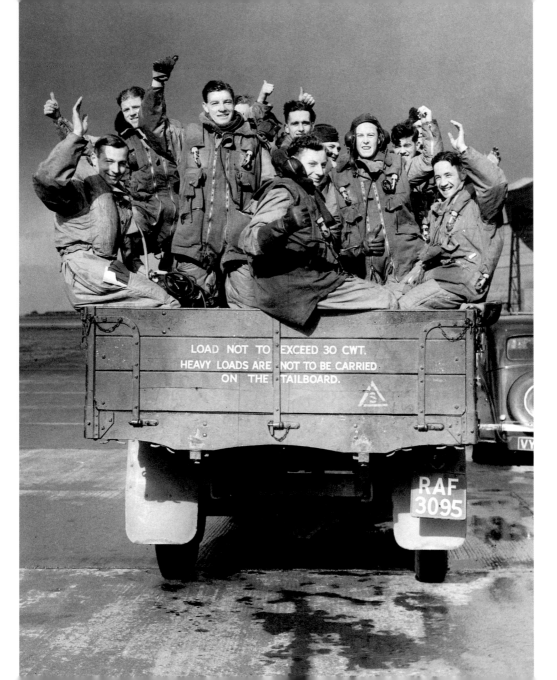

LOAD NOT TO EXCEED 30 CWT.
HEAVY LOADS ARE NOT TO BE CARRIED
ON THE TAILBOARD.

RAF
3095

During a raid on Cologne, Germany, on the night of 12–13 November 1940, Whitley bomber P5005, 'N for Nuts', of No. 102 Squadron, was damaged by anti-aircraft rounds exploding close to the aircraft. The explosion blew open a 15-foot section of the fuselage. Despite this, the pilot, Flying Officer Leonard Cheshire, successfully dropped the aircraft's bomb load on the target, and safely returned to RAF Linton-on-Ouse, Yorkshire.

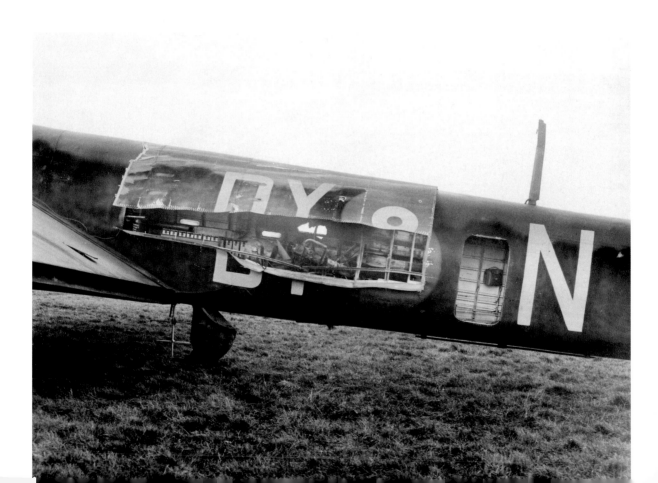

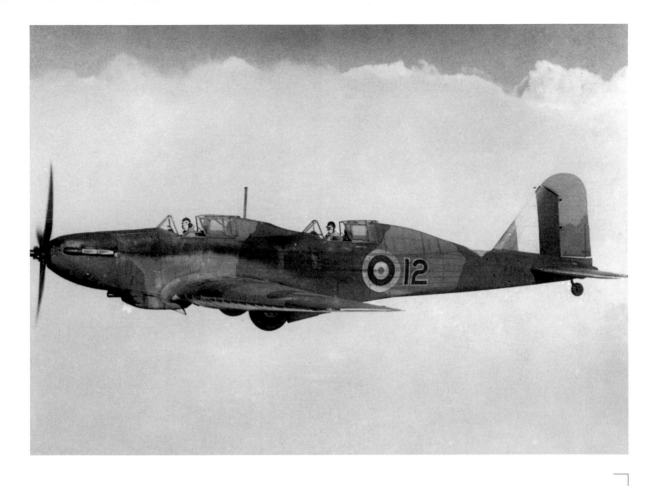

Fairey Battle trainer, R7365, of No. 1 Service Flying School at RAF Netheravon takes to the skies over Wiltshire in February 1941. Aircraft like this one were used to give trainee bomber pilots valuable flying experience.

Vickers Wellesley K7775, of No. 47 Squadron, based at Agordat, Eritrea, in flight following the Battle of Keren in April 1941.

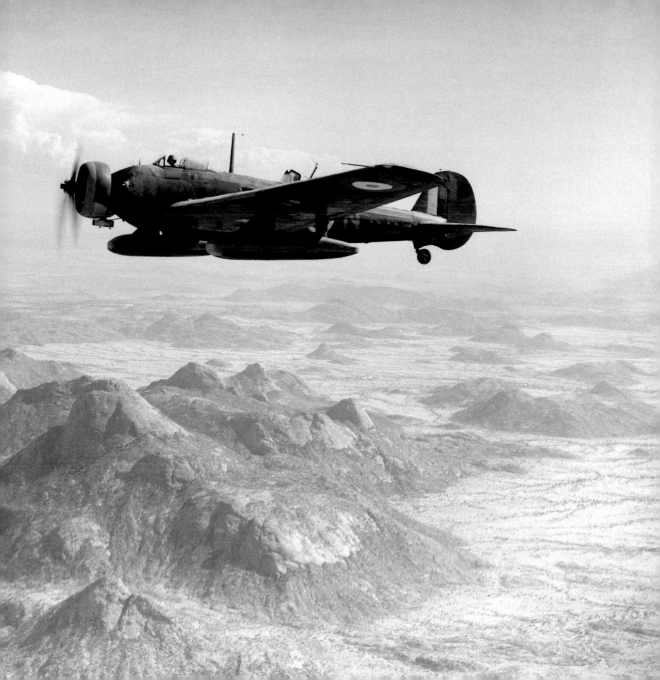

The crew of Boeing Fortress I of No. 90 Squadron prepare to embark their aircraft at RAF Polebrook, Northamptonshire, in June 1941, for an attack on the German battlecruiser *Gneisenau* while the ship was docked in France.

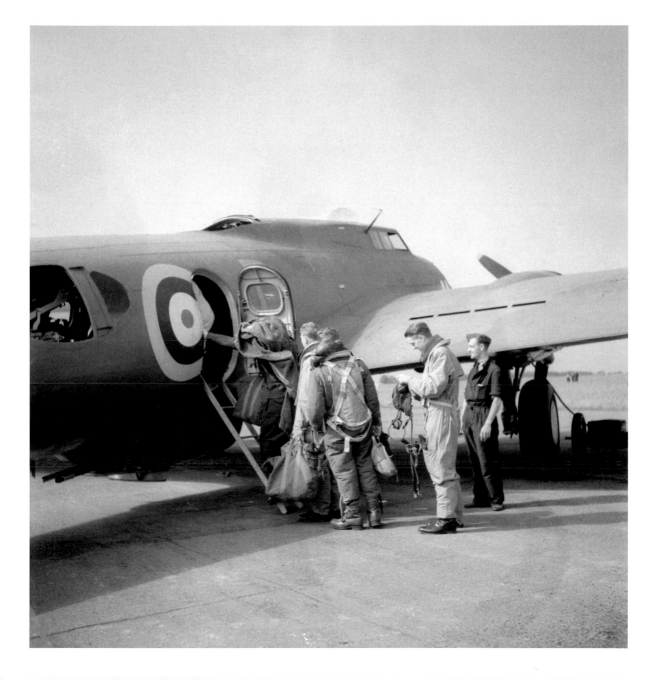

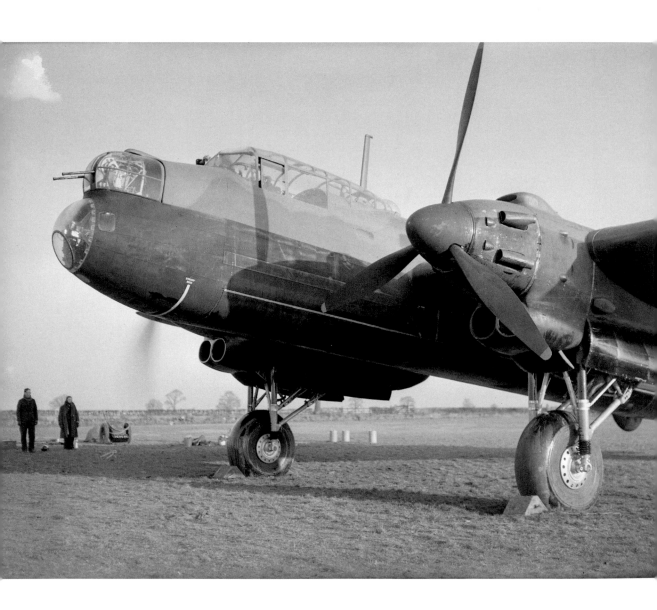

An Avro Manchester of No. 207 Squadron at RAF Waddington, Lincolnshire, with one of its two Rolls-Royce Vulture II engines run up in September 1941. The Manchester was not considered to be a great success due to the unreliability and poor power of the Vulture engines. It was redeveloped into the four-engine Avro Lancaster.

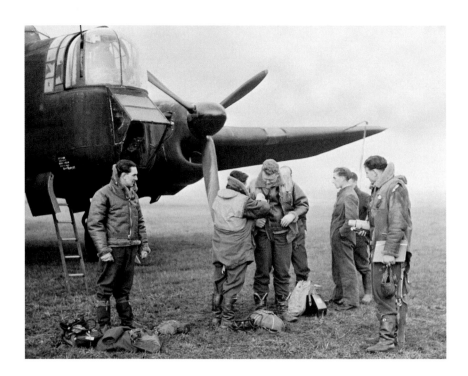

A Whitley crew prepares for a
night sortie in November 1941.
The ground crew wait patiently as
last-minute adjustments are made
to the pilot's flying clothing at
dispersal. Note the parachutes and
map bags on the ground, and the
thermos flask — an essential item of
personal kit for a seven-hour flight
in a cold and draughty Whitley.

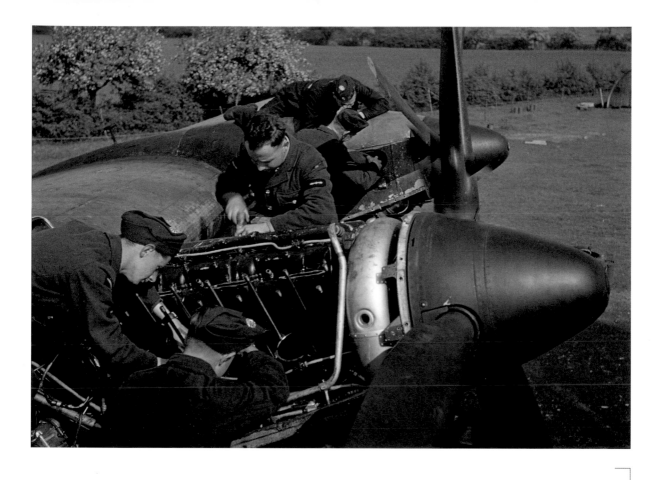

RAF mechanics work on a Merlin engine fitted to a Handley Page Halifax B.II of No. 35 Squadron at RAF Linton-On-Ouse in Yorkshire, June 1942.

The personnel required to keep one Avro Lancaster operational at RAF Scampton, Lincolnshire, in June 1942. The crew included left to right: flying control officer, Women's Auxiliary Air Force (WAAF) parachute packer, meteorological officer, seven aircrew, twelve maintenance crew, five mechanics, three bombing-up crew, a WAAF tractor driver, seventeen ground-servicing crew, an AEC Matador petrol tender with two crew and a mobile workshop with three crew.

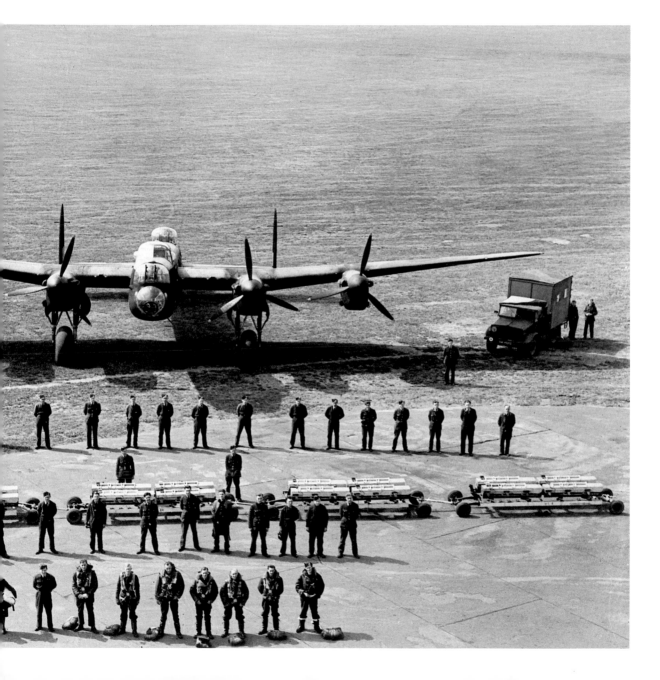

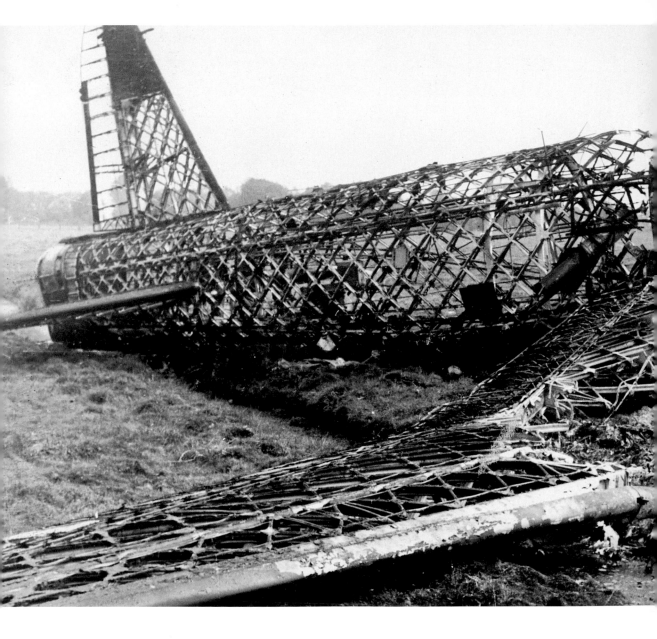

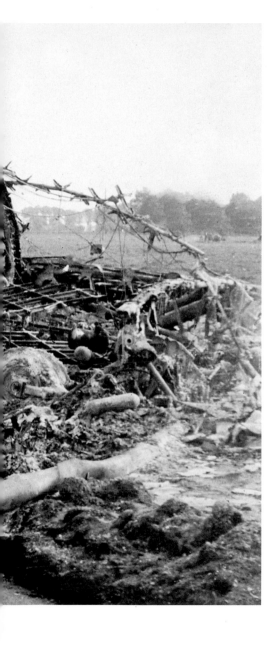

The wreckage of a Vickers Wellington
after being shot down on the night
of 13–14 September 1942 while on
a raid to Bremen, Germany. Recent
research suggests the aircraft is Z1385
of No. 460 Squadron Royal Australian
Air Force (RAAF) from RAF Breighton,
Yorkshire – none of the crew survived.

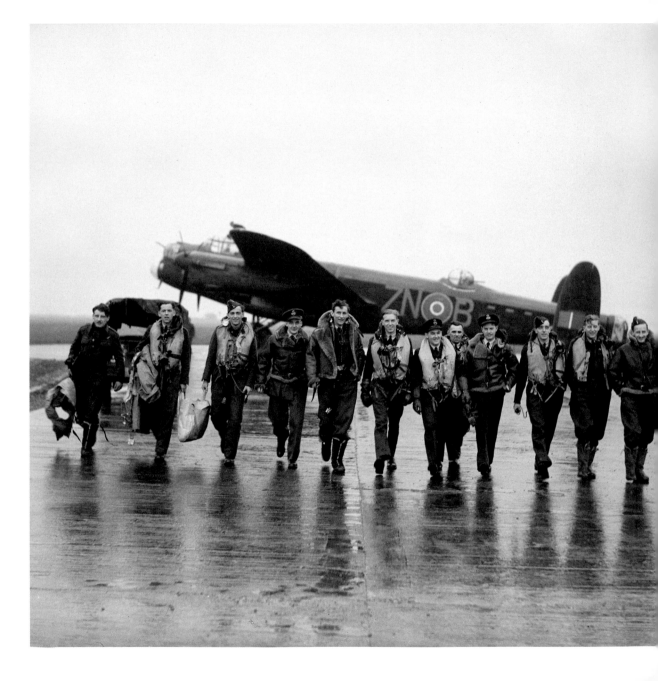

Aircrew from No. 106 Squadron walking across the dispersal area at RAF Syerston, Nottinghamshire, after safely returning from a raid on Genoa, Italy, 22–23 October 1942. Fourth from the right is Pilot Officer David Shannon, who the following year took part in Operation Chastise (Dambusters Raid), the famous attack on the German dams.

The crew of Short Stirling I, N3676, of
No. 1651 Heavy Conversion Unit at RAF
Waterbeach, Cambridgeshire, walk dressed
in full flying kit beneath the nose of the
aircraft, while the ground crew run up the
engines. The unit was formed to convert
newly trained aircrew onto the type of
aircraft they would fly operationally.

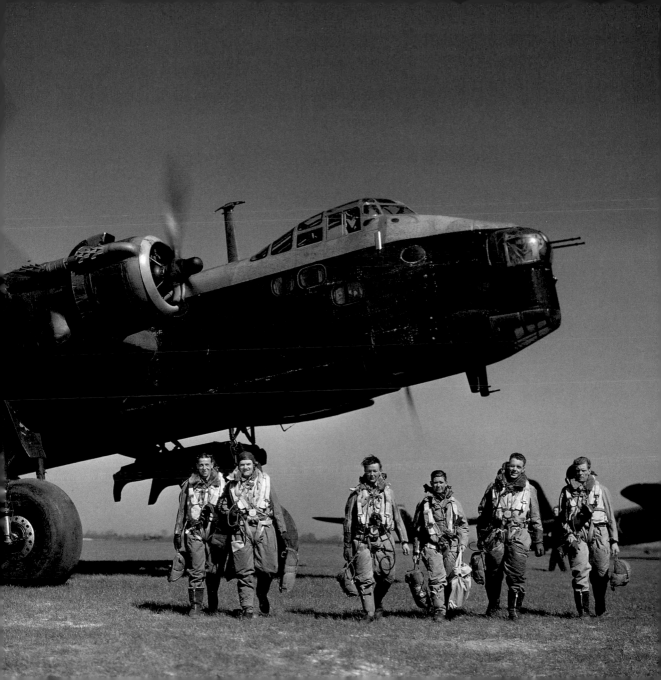

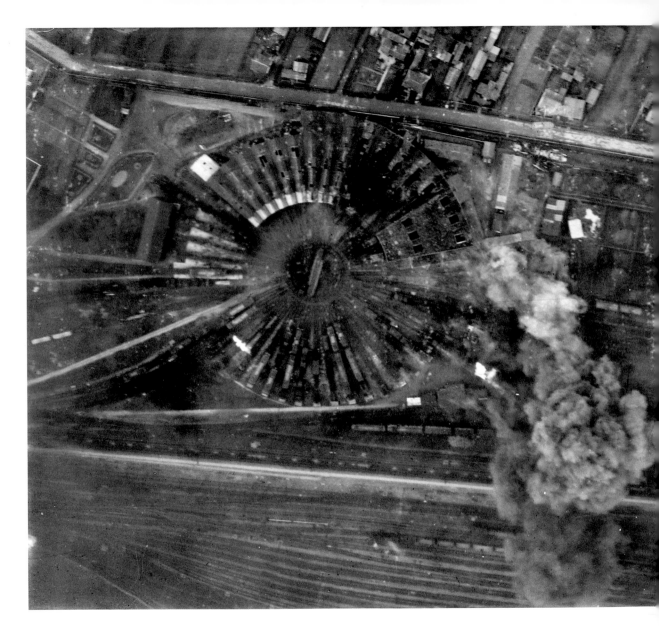

Aerial photograph taken during an attack by de Havilland Mosquito B Mk IVs, of No. 139 Squadron RAF, on the locomotive sheds at Tours, France, in February 1943. Bombs burst across the railway track and engine sheds, on the roofs of which extensive damage can be seen from a raid the previous day by No. 139 Squadron.

Wing Commander Guy Gibson and his crew prepare to board Lancaster ED932, 'G for George', at RAF Scampton. As Commanding Officer of No. 617 Squadron, Gibson led Operation Chastise, the successful raid on the Möhne, Eder and Sorpe dams in Germany on the night of 16–17 May 1943.

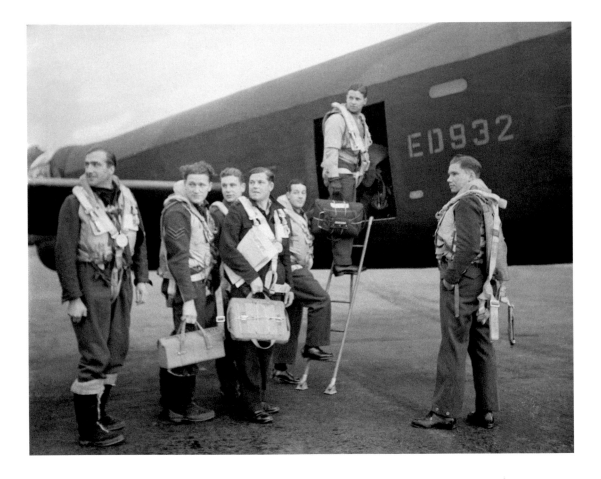

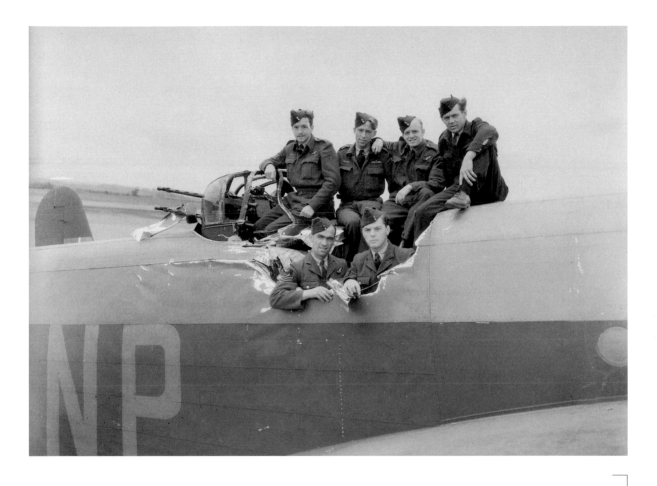

The crew of Handley Page Halifax B Mk.II, HR837, of No. 158 Squadron pose in their damaged aircraft at RAF Lissett, Yorkshire. The aircraft was hit by a falling bomb from another Halifax on a raid to Cologne, Germany, on the night of 28–29 June 1943.

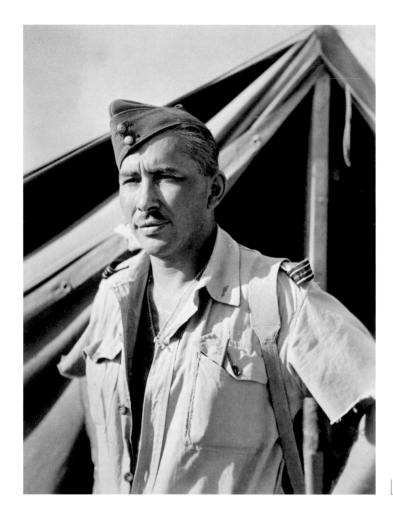

Flight Lieutenant Robert James McCombe, of No. 424 Squadron Royal Canadian Air Force (RCAF), was awarded the George Medal for bravery for rescuing personnel while the bomb load of a Vickers Wellington exploded around him.

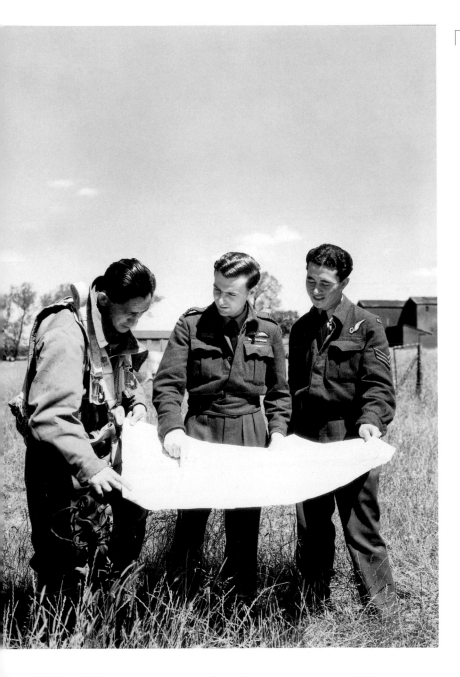

Three airmen from New Zealand examine a map together at an airfield in Britain, 1943. In the middle is Squadron Leader Fraser Barron DSO, DFC, DFM (pilot), with Maoris Sergeant Tame Hawaikirangi Waerea (air gunner) on the left, and Sergeant Charles Mito Hilairo Pinker DFC (navigator) on the right. Pinker was the only one to survive the war.

An unnamed pilot of No. 15
Squadron stands in front of a Short
Stirling bomber at RAF Mildenhall,
Suffolk, in October 1943.

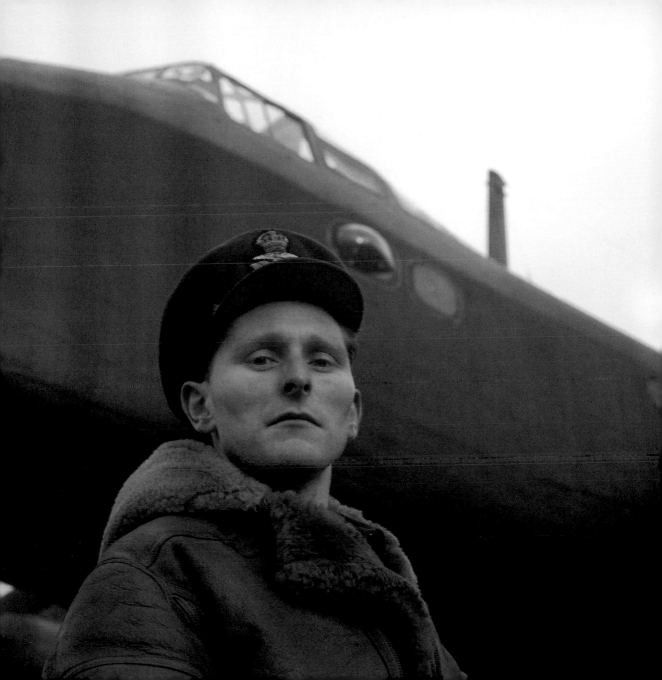

The view from the rear gunner's position of a Wellington bomber being assembled in Hawarden Aircraft Factory, Flintshire, 1943. It was at this factory that a record attempt was made to assemble a Wellington from scratch in just 24 hours.

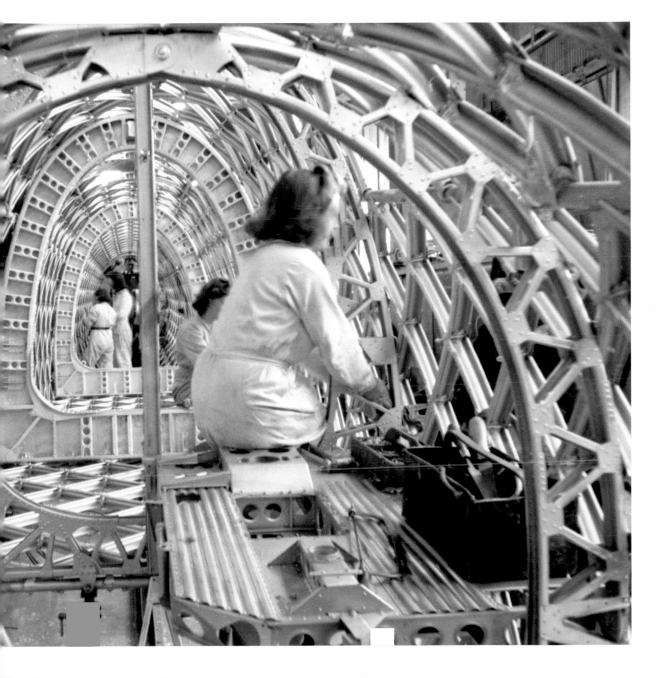

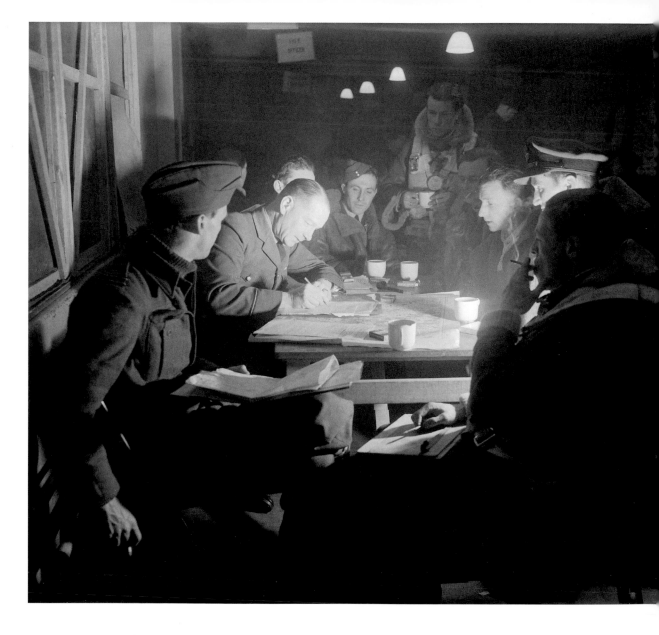

The crew of a Short Stirling B Mk.III of No. 622 Squadron reporting their experiences to an intelligence officer at RAF Mildenhall, Suffolk, after a major raid on Berlin, Germany, on the night of 22–23 November 1943. Left to right: Flight Lieutenant R D Mackay (navigator), Flying Officer G Dunbar (interrogating officer), Sergeant J Towns (rear gunner) Pilot Officer K Pollard (wireless operator), Flight Sergeant C Stevenson (second pilot), Squadron Leader J Martin (captain and flight commander), Sergeant W Rigby (mid-upper gunner), Flying Officer Grainger (bomb aimer) and Sergeant H Fletching (flight engineer).

A WAAF spark plug tester cleans and tests an Avro Lancaster's 96 spark plugs in 1943. The spark plugs for three Lancasters (R5667, ED712 and ED720) can be seen in the background. All three aircraft were lost before the end of the year.

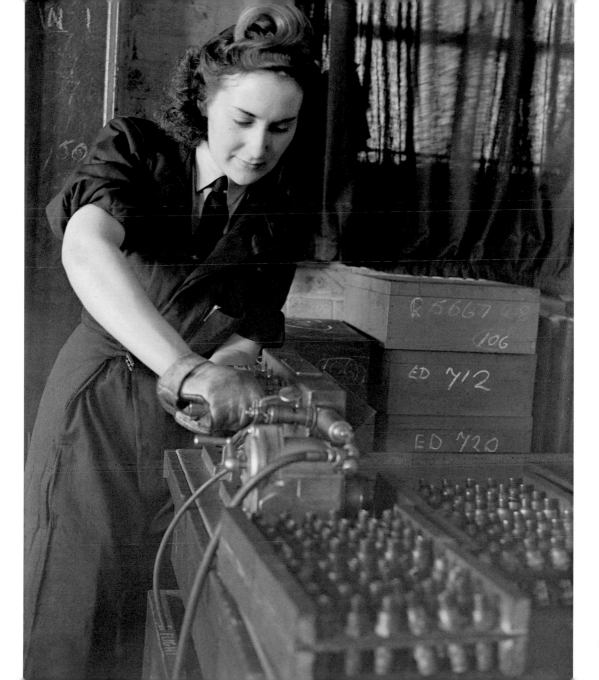

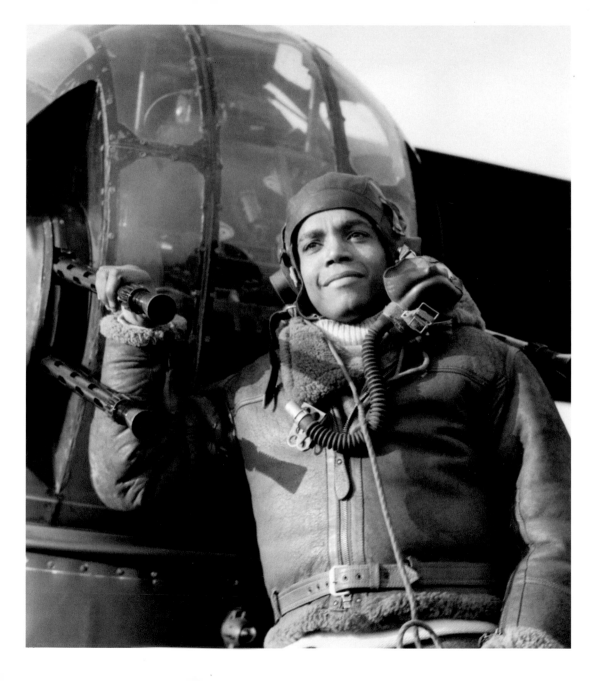

Lincoln Orville Lynch DFM, a Jamaican air gunner, volunteered to join the RAF in 1942. On successfully passing his training in 1943 he joined No. 102 Squadron, equipped with the Handley Page Halifax at RAF Pocklington. On his first mission Lynch successfully shot down a German Junkers Ju 88 night fighter.

A factory worker manufactures aluminium tinfoil strips known as chaff in 1943. Developed by Welsh physicist Joan Strothers, and originally given the codename of 'Window', chaff was dropped by aircraft to confuse enemy radar and conceal the aircraft's location.

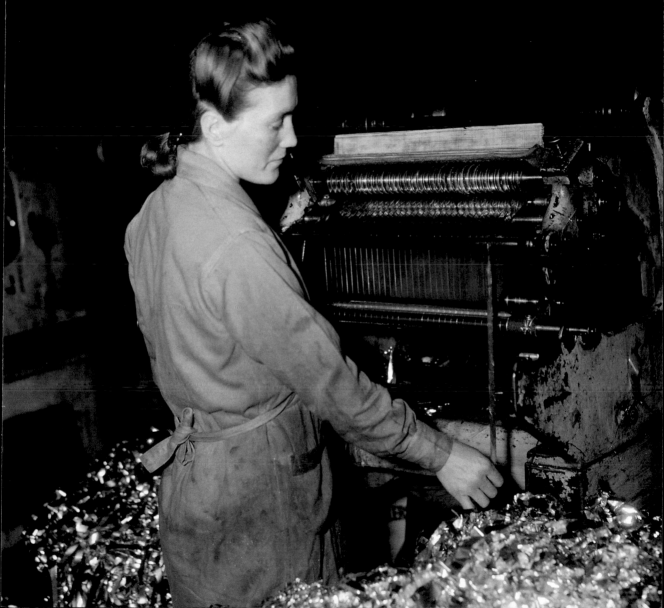

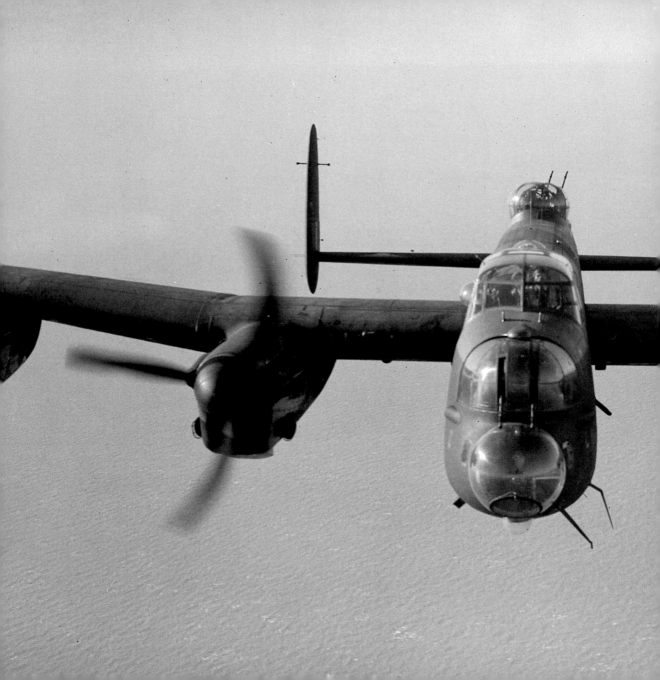

An Avro Lancaster B.III of No. 619 Squadron on a test flight from RAF Coningsby, Lincolnshire, in February 1944.

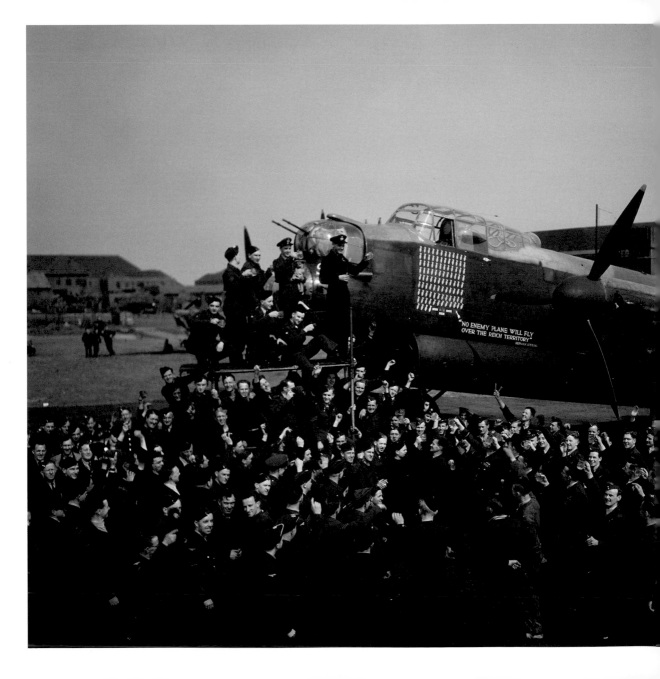

Personnel of No. 467 Squadron RAAF gather with Avro Lancaster B.1, R5868 'S for Sugar', at RAF Waddington, Lincolnshire, to celebrate the aircraft's successful completion of 100 operations in May 1944. R5868 entered service with No. 83 Squadron RAF in June 1942. By the end of the war the aircraft had flown over 100 sorties with the RAF and RAAF.

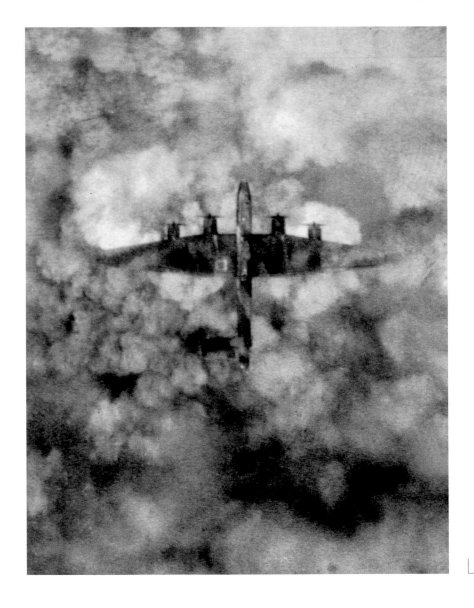

Aerial photograph showing Handley Page Halifax B Mk.III, LW127 'AL-F', of No. 429 Squadron RCAF, flown by Flight Lieutenant George W Gardiner, in flight over Mondeville, France, after losing its entire starboard tailplane to bombs dropped by a Halifax above it.

RAF and WAAF intelligence officers and their staff at work in the map section in the Operations Block at Headquarters, Bomber Command, near High Wycombe, Buckinghamshire in 1944.

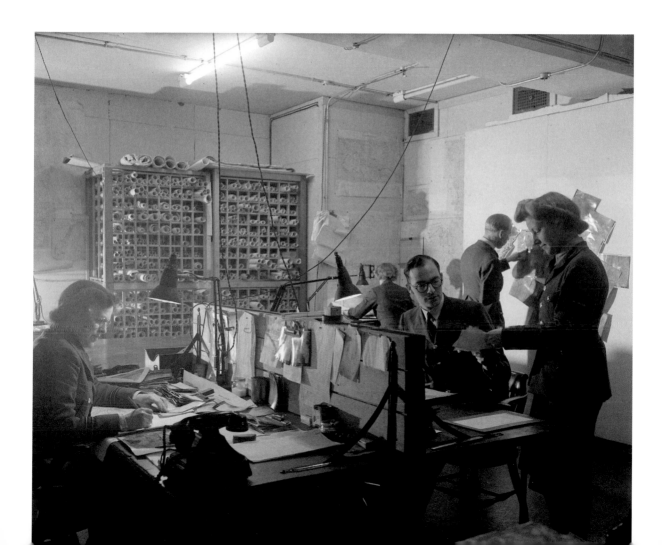

A member of the crew of Avro Lancaster B.III, LM429, of No. 50 Squadron disembarks from the aircraft, while two members of the groundcrew can be seen reflected in rainwater beneath the aircraft. LM429 was shot down over Belgium on the night of 10–11 May 1944, with the loss of all the crew.

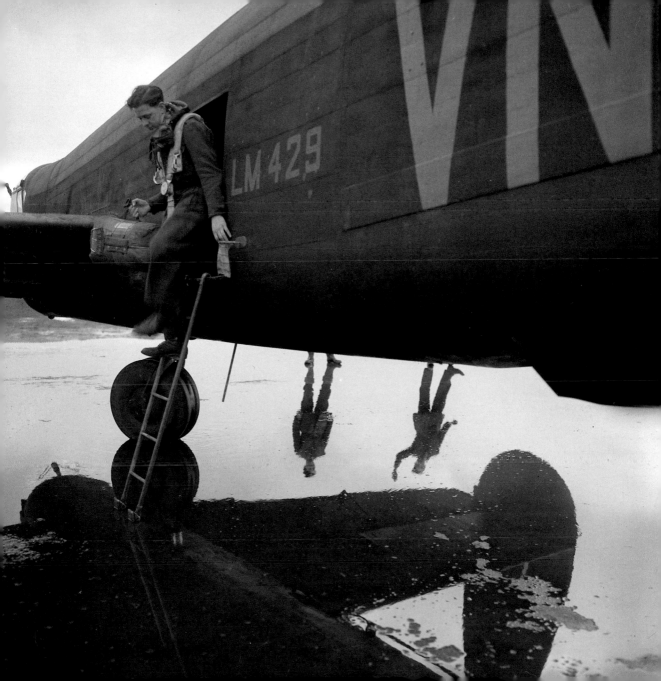

The New Zealander crew of Avro Lancaster B.III, NE181, of No. 75 (NZ) Squadron RAF celebrate the aircraft's 101st successful sortie at RAF Mepal, Cambridgeshire, 1945. No. 75 Squadron was the first Commonwealth squadron to be formed during the Second World War.

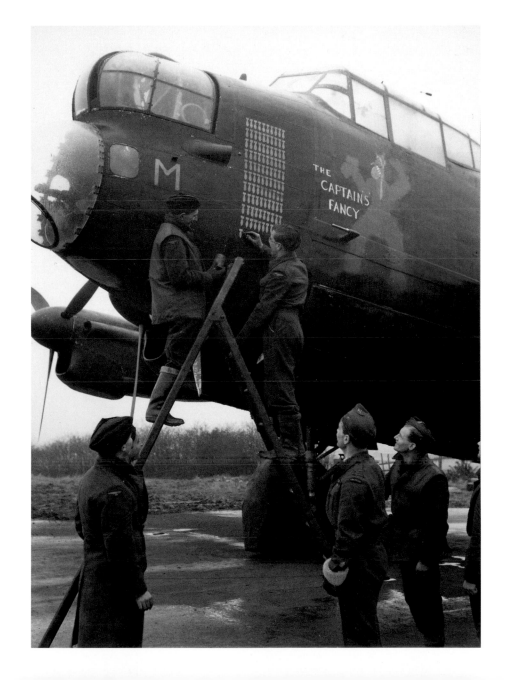

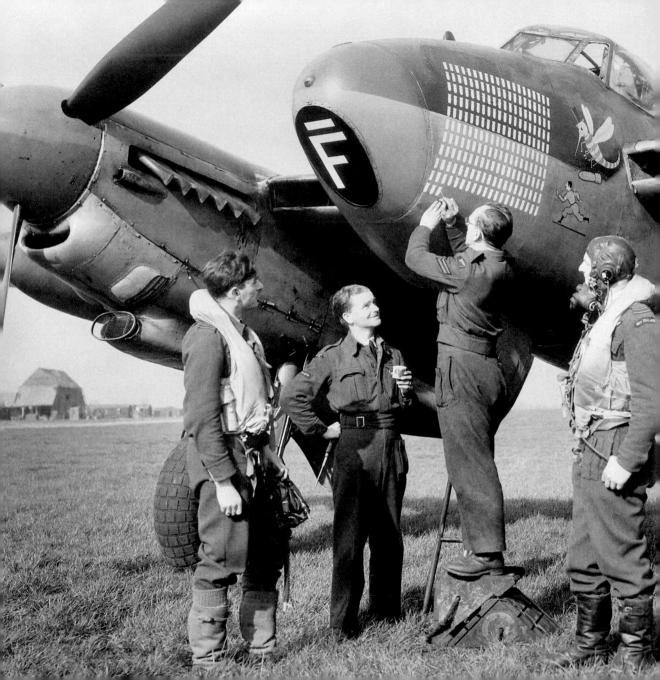

The crew of de Havilland Mosquito B Mk IX, LR503, of No. 105 Squadron record the aircraft's 203rd sortie on the aircraft's nose at RAF Bourn, Cambridgeshire, in April 1945. LR503 went on to complete 213 sorties, more than any other aircraft in Bomber Command during the Second World War.

A low-level aerial photograph of the devastated city centre of Stuttgart, Germany, taken in May 1945, after 53 major raids, most of them by Bomber Command, destroyed nearly 68 per cent of the built-up area and killed 4,562 people.

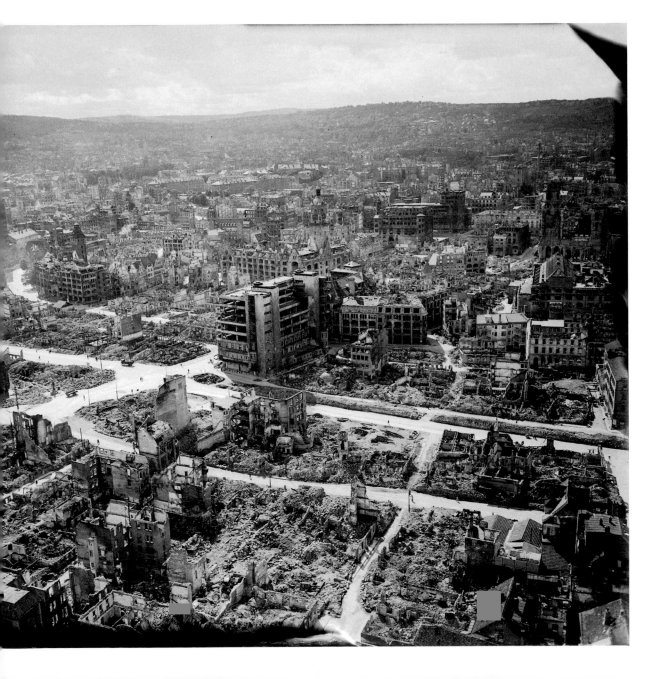

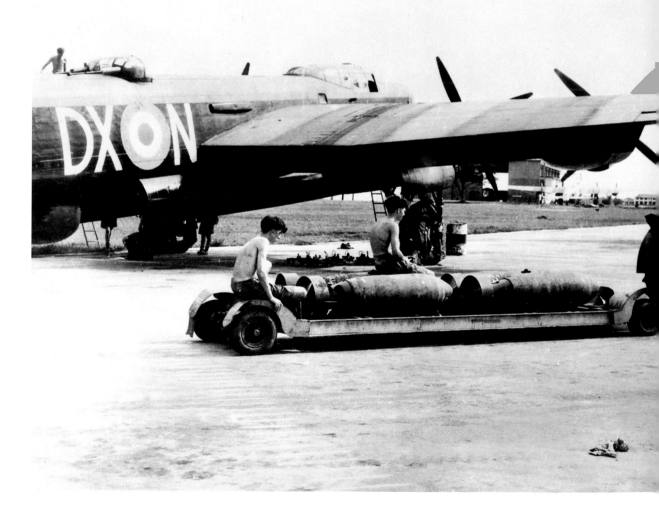

An Avro Lincoln bomber of No. 57 Squadron is readied at RAF Tengah, Singapore, for a bombing raid on Malayan pro-independence fighters during the Malayan Emergency in 1950.

Three English Electric Canberra B6 bombers of No. 101 Squadron in flight over Lincolnshire. Based at RAF Binbrook, No. 101 Squadron was the first RAF squadron to be equipped with the Canberra when it entered service.

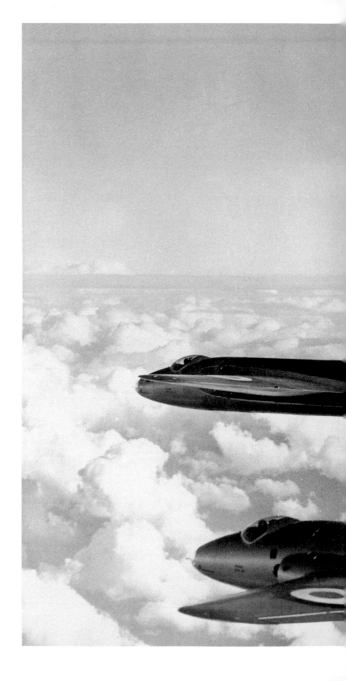

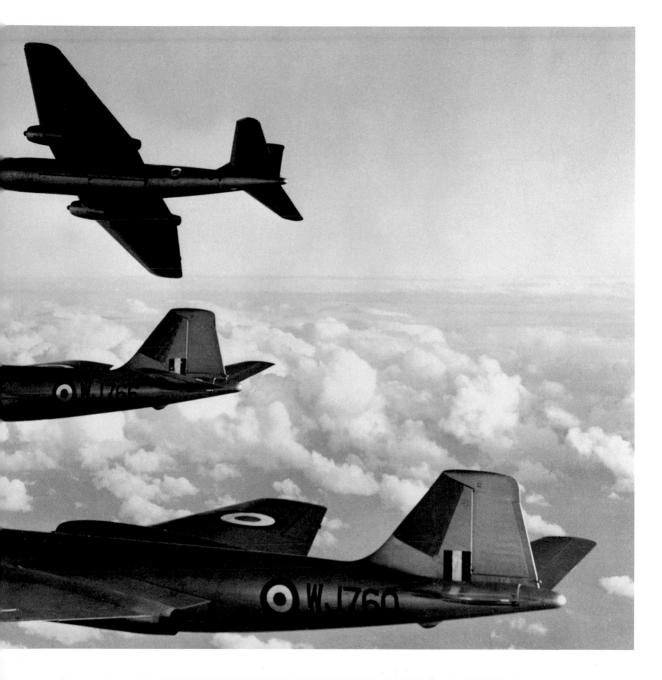

The crew of Vickers Valiant B(K) 1, XD823, of No. 49 Squadron at RAF Wittering before departing for Operation Grapple, March 1957. Left to right: Flight Lieutenant David Crowther (navigator), Flight Lieutenant Donald Bridges DFC (co-pilot), Squadron Leader Arthur Steele AFC, Chief Technician WR Quinlan (crew chief), Flight Lieutenant Wilfred Jenkins (navigator and bomb aimer) and Flying Officer Charles Scanlan (air signaller).

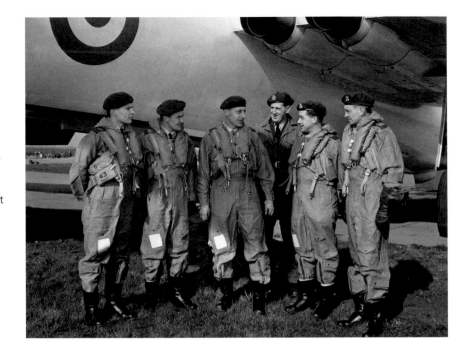

The three V bombers in flight together from RAF Gaydon, January 1958. The first Handley Page Victor B.1 delivered, XA931, of No. 232 Operational Conversion Unit (OCU), is on the left, led by Avro Vulcan B.1, XA904, of No. 83 Squadron, with Vickers Valiant B(K)1, XD869, of No. 214 Squadron on the right.

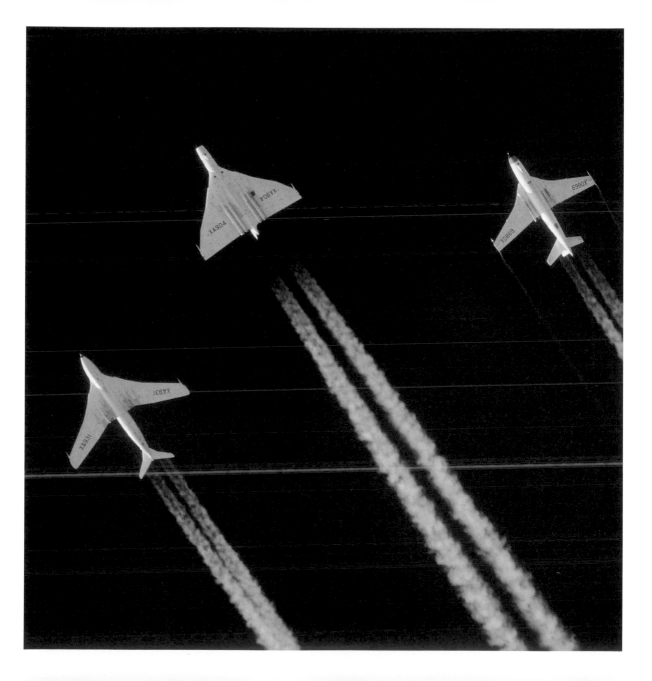

A crew member of a Handley Page
Victor looks out from the bomb
aiming position of a Victor B.1
at RAF Cottesmore, Rutland.

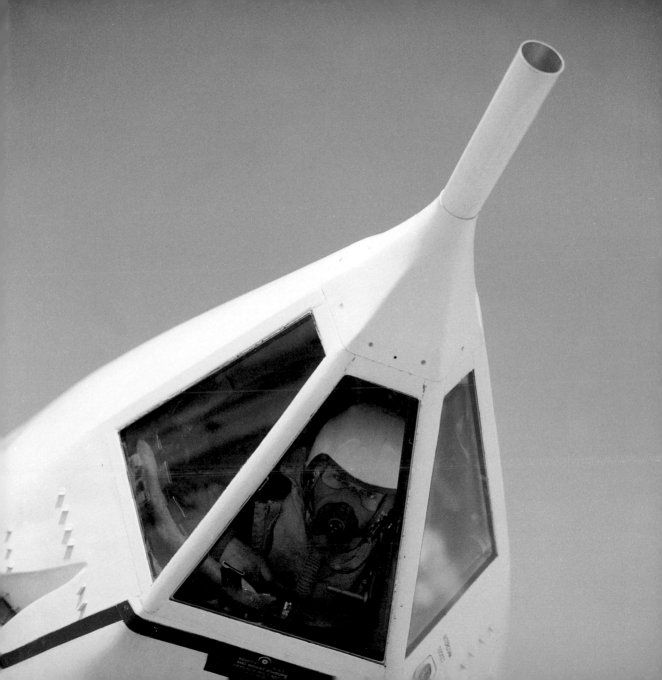

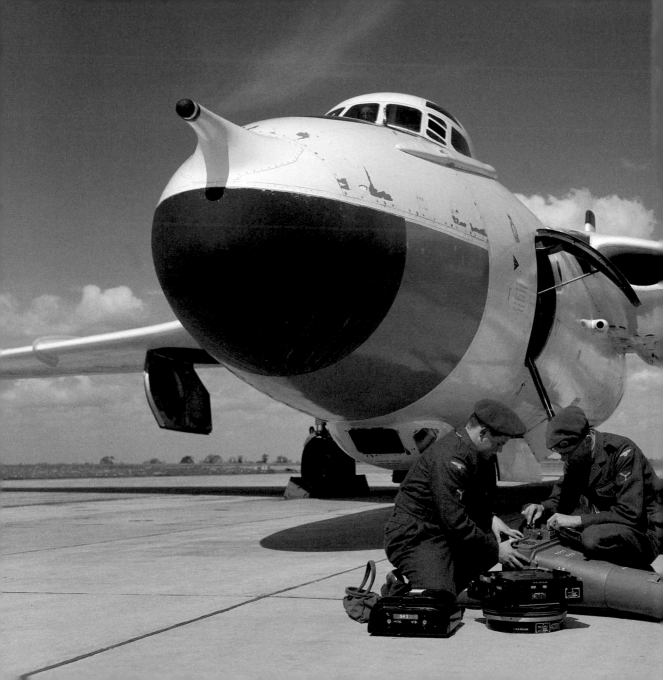

A F.52 camera is checked before being installed in a Vickers Valiant B(PR)1 of No. 543 Photo Reconnaissance Squadron at RAF Wyton, Huntingdonshire, 1960. Originally operational between 1942 and 1943, No. 543 Squadron was reformed in 1955 to provide pre- and post-strike reconnaissance for the V bomber force. The latter function was soon declared obsolete due to its impracticality in the event of a nuclear attack.

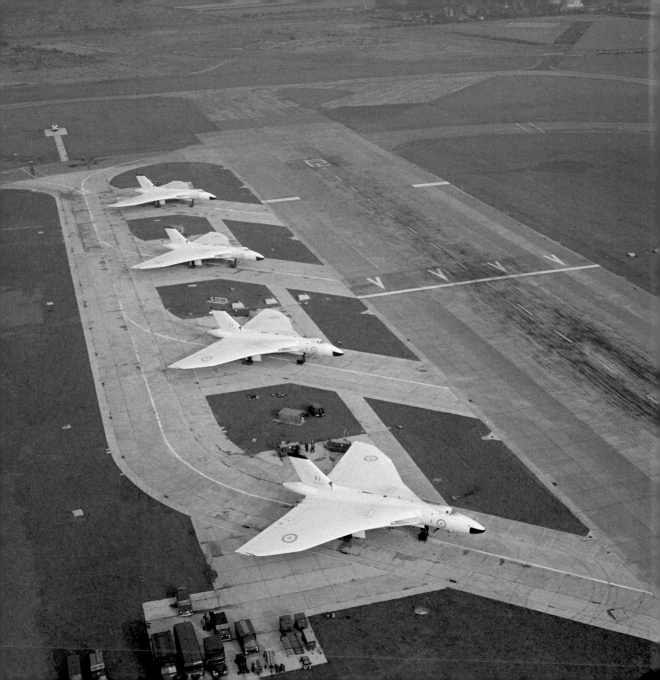

An aerial view of four Avro Vulcan B.2 aircraft of No. 83 Squadron taken during a dispersal exercise at RAF Finningley, Yorkshire, in 1962. The aircraft are positioned on the Operational Readiness Platform, with all electrical power and the Auxiliary Power Unit on, and the crew fully suited and in position. From this state of readiness, the aircraft could be airborne in fewer than five minutes.

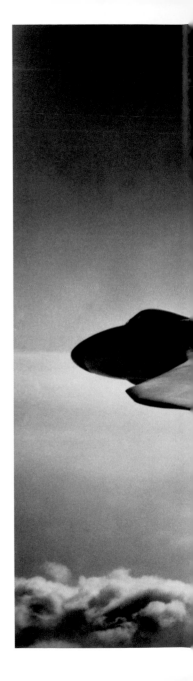

Avro Vulcan B.2, XH534, takes to the skies in 1962. XH534 was the second B.2 produced and was originally operated by Aeroplane and Armament Experimental Establishment at MOD Boscombe Down as a trials aircraft, before serving with No. 230 OCU and No.27 Squadron.

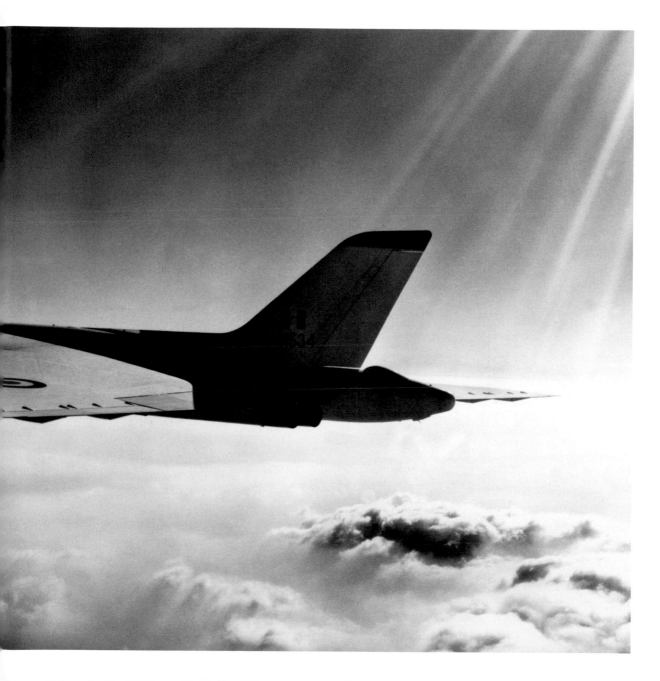

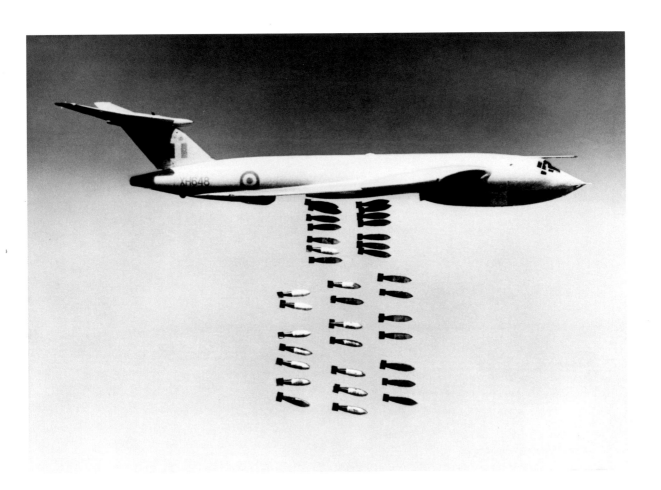

Handley Page Victor B1a, XH648, of No. 15
Squadron RAF drops its load of 1000lb bombs
during the Indonesian Confrontation in 1963.
XH648 is the only Victor to have dropped a full
bomb load and is now on permanent display at
IWM Duxford following a major restoration.

Image List

About the Author

Rebecca Greenwood Harding is Head of Technological Objects
at IWM. Based at IWM Duxford she joined IWM in 2001 and
worked in a number of different curatorial roles until taking on
her current role in 2019. Her areas of particular interest include
aviation during the Second World War, Britain's nuclear weapons
development and testing programme in the 1950s, post-1945
armoured vehicle development and popular culture during
the Cold War.

Acknowledgements

The author would like to thank colleagues Lara Bateman
(Publishing Officer) and Helen Mavin (Head of Photographs)
for their help with this book. Thanks also to Bryn Hammond
(Principal Curator, Collections) for his help with this book and
for his support in general. To my mother June and husband
Stuart, thank you for everything. This book is dedicated to my
late much-loved father, Peter Greenwood, who encouraged my
interest in historic aviation from an early age.